TONY HOPKINS AND WE DID OK, KID (COMMENTARY AND REFLECTIONS)

Copyright © 2025 by Henry Everson

Title: Tony Hopkins and We Did OK, Kid (Commentary and Reflection)

Subtitle: On Art, Aging, and the Grace of Looking Back

Author: Henry Everson

Publication Date: 2025

ISBN: 978-1-257-24761-5

No section of this publication may be reproduced, stored in a retrieval system, or transmitted in any form or by any means — electronic, mechanical, photocopying, recording, scanning, or otherwise — without the prior written permission of the author or publisher, except in the case of brief quotations used in reviews, critical articles, or educational materials with proper acknowledgment.

CONTENTS

Chapter 1: The Early Years and the Making of an Actor

SECTION 1: Beginnings – Childhood, Family, and First Encounters with Art
SECTION 2: Discovering the Stage – Training, Theater, and Early Roles
SECTION 3: Lessons Learned – Early Failures, Mentors, and Pivotal Moments

Chapter 2: The Craft of a Lifetime

SECTION 1: Character and Transformation – Understanding Roles and Empathy
SECTION 2: Technique and Instinct – Balancing Discipline with Spontaneity
SECTION 3: Iconic Performances – Reflections on Memorable Roles

Chapter 3: Art in Context

SECTION 1: Film, Theater, and Beyond – The Mediums That Shaped Him
SECTION 2: Collaboration – Working with Directors, Co-actors, and Creative Teams
SECTION 3: Influence and Inspiration – How His Work Resonates Across Generations

Chapter 4: Aging, Perspective, and Grace

SECTION 1: Time and Transformation – Aging as an Actor and Human Being
SECTION 2: Reflection and Acceptance – Facing Choices, Mistakes, and Triumphs
SECTION 3: The Wisdom of Experience – Sharing Knowledge and Leaving a Legacy

Chapter 5: Looking Back, Moving Forward

SECTION 1: Memoirs and Musings – Personal Insights Beyond the Screen

SECTION 2: The Intersection of Life and Art – What We Carry Forward

SECTION 3: Gratitude and Continuity – Finding Meaning in the Journey

Chapter 1: The Early Years and the Making of an Actor

SECTION 1: Beginnings – Childhood, Family, and First Encounters with Art

Every actor's journey begins somewhere, often in the quiet and unassuming corners of childhood. These early years are crucial, for they form the emotional and imaginative foundation upon which a career in performance is built. For many actors, the spark of creativity is ignited long before formal training, often through family influence, exposure to the arts, or even the imaginative play that children naturally engage in. The early years are a delicate balance of observation and experimentation, curiosity and imitation, as young minds absorb the textures of the world around them.

In the earliest memories of any aspiring actor, family life plays an indispensable role. Parents, siblings, and even extended relatives often form the first audience. The way a child interacts with their family can subtly shape their emotional intelligence, an attribute indispensable for acting. Supportive households, where curiosity is encouraged and storytelling is valued, provide fertile soil for early artistic impulses. Conversely, even restrictive or chaotic environments can serve as unexpected catalysts, compelling children to turn inward, to create imaginary worlds, or to explore characters as a form of escape or understanding.

Childhood exposure to art, whether visual, musical, or literary, leaves lasting imprints. For an actor, the first encounter with a story that resonates emotionally can be transformative. Perhaps it is a vividly illustrated book that captures a young mind's imagination, or a local theater production that illuminates the power of performance. These moments, seemingly simple in their immediacy, plant seeds of empathy and narrative understanding. A child watching a play, captivated by the actor's embodiment of a character, begins to learn the subtle mechanics of human emotion—the shifts in tone, gesture, and expression that convey meaning beyond words.

Even before formal schooling, play serves as the first rehearsal space for the budding actor. Role-playing, whether with peers or alone, allows children to experiment with identity, voice, and movement. A child who insists on playing the teacher, the parent, or even fantastical figures, is practicing empathy, improvisation, and narrative structure—all fundamental skills for later professional work. In these exercises, the young actor confronts the first small challenges of inhabiting someone else's perspective, a practice that will later define the depth and authenticity of their performances.

In families where art is not overtly emphasized, chance encounters can still ignite the imagination. A neighbor's piano recital, a visit to a local museum, or even the accidental witnessing of a public performance can awaken a curiosity for the stage. These experiences are often remembered not for their grandiosity, but for the emotional impression they leave. The child senses the magic of transformation, the power of being seen and heard in a concentrated moment, and is drawn to it with a quiet, persistent fascination.

SECTION 2: Discovering the Stage – Training, Theater, and Early Roles

The journey from curiosity to commitment begins in earnest with formal or semi-formal encounters with acting, whether through school programs, community theater, or private classes. It is during this phase that a young actor begins to understand not only the craft but also the discipline that the art requires. Early training introduces foundational skills—voice modulation, movement, diction, and character analysis—but it also begins to teach resilience, humility, and the understanding that artistry is cultivated over time.

For many, the first steps onto a theater stage are both exhilarating and terrifying. The theater, with its bright lights and expectant audience, can be a proving ground where fear and passion collide. Early roles, whether minor or major, offer critical opportunities for learning. The novice actor quickly discovers that the rehearsal room is a space of collaboration, negotiation, and patience. The technical demands—blocking, line memorization, stage presence—are coupled with the emotional labor of becoming someone else convincingly. This duality of craft and emotion is what begins to distinguish a true actor from someone who merely performs.

The influence of mentors at this stage cannot be overstated. Teachers, directors, and older actors serve as guides, providing not only technical instruction but also modeling professionalism and creative integrity. A mentor's encouragement or constructive critique can affirm the young actor's abilities and push them to explore the boundaries of their craft. These relationships often become pivotal, shaping career trajectories and instilling principles that will govern the actor's approach for decades to come.

Early theater experiences also offer lessons in adaptability and observation. School plays, amateur productions, or small local theaters expose young actors to different genres, styles, and approaches. Comedy teaches timing and audience awareness; tragedy teaches emotional depth and restraint; musicals teach discipline in synchronizing movement and voice. Each production, regardless of scale, offers a laboratory for experimentation. Mistakes are inevitable, but they are equally essential, providing immediate feedback and the opportunity for growth.

Furthermore, these formative experiences often cultivate a deep appreciation for collaboration. Acting is rarely a solitary endeavor; it is an intricate dance with fellow performers, directors, stage crew, and even the audience. Early exposure to ensemble work teaches young actors to listen, respond, and co-create. They learn that acting is not merely about individual talent but about the collective energy that produces a compelling performance. This understanding fosters humility and the recognition that the stage is a shared space where each contribution matters.

SECTION 3: Lessons Learned – Early Failures, Mentors, and Pivotal Moments

No actor's path is linear, and early failures are as instructive as successes. Auditions that do not result in roles, performances that fail to resonate with audiences, or personal missteps on stage teach resilience. These experiences challenge the actor to confront self-doubt, refine technique, and develop emotional stamina. In fact, many of the most enduring lessons come not from applause, but from the moments when ambition meets limitation. The capacity to analyze failure critically, to extract lessons without internalizing defeat, is foundational to a sustained acting career.

Mentorship remains central during these early challenges. The guidance of a seasoned actor or teacher can illuminate the way forward, offering perspective when setbacks feel insurmountable.

Mentors demonstrate that failure is not a reflection of inadequacy but an essential part of the artistic process. They model how to maintain integrity and professionalism, and how to keep curiosity alive even amid rejection. For young actors, these relationships often serve as both emotional lifelines and intellectual guides.

Pivotal moments—those instances that seem to crystallize a career—are often subtle and unanticipated. A single performance may reveal previously undiscovered depth, an audition may open doors to opportunities previously unimagined, or a fleeting exchange with an experienced artist may change the actor's approach forever. These moments are not always spectacular; sometimes they are quiet revelations, internal confirmations that the path chosen is meaningful and attainable. For many actors, recalling these early breakthroughs later in life provides both inspiration and reassurance, evidence that perseverance and dedication yield tangible growth.

Early failures also teach adaptability. An actor learns that scripts, roles, and audiences vary widely; what works in one context may falter in another. These experiences cultivate creative problem-solving, as the actor navigates character inconsistencies, unexpected staging challenges, or even personal limitations. The capacity to pivot, to adjust while remaining authentic, becomes a core professional skill. Equally important is the lesson in self-awareness: recognizing one's strengths and weaknesses allows the actor to pursue roles strategically, develop technique thoughtfully, and maintain realistic expectations while pushing artistic boundaries.

The early years also cultivate emotional intelligence, a quality often cited as essential for performance. Actors observe, internalize, and translate human behavior into nuanced expression. Childhood curiosity, family dynamics, and early artistic encounters combine with training to foster empathy—the ability to inhabit perspectives vastly different from one's own. This emotional literacy is what distinguishes a compelling actor from one who merely recites lines. It is the foundation for authenticity on stage and screen, allowing the performer to connect profoundly with audiences.

Moreover, these formative years often shape the actor's ethical framework and approach to the profession. Integrity, professionalism, and respect for collaborators are learned through the combination of training, observation, and trial and error. The young actor begins to understand

that talent alone is insufficient; consistency, diligence, and respect for craft are equally important. Early exposure to these principles ensures that as the actor matures, they carry not only technical skill but also a professional ethos that sustains long-term success.

Finally, early achievements and setbacks alike contribute to the formation of identity. The actor learns who they are, what drives them, and how they wish to be perceived by the world. They recognize the exhilaration of embodying someone else while understanding the necessity of retaining one's authentic self. This dual awareness—the interplay between transformation and self-knowledge—becomes a defining feature of an actor's career. It informs choices about roles, collaborations, and artistic directions, and it underpins the resilience necessary to navigate the inevitable uncertainties of the profession.

The combination of mentorship, early experience, and reflective learning creates a foundation upon which the actor's later work is built. Childhood curiosity evolves into disciplined exploration; imaginative play develops into technical mastery; early failures transform into lifelong lessons in resilience and adaptability. By the end of this period, the young actor is no longer merely an enthusiastic participant in the arts but a student of humanity, of emotion, and of narrative. They have glimpsed both the beauty and the challenges of the craft and are prepared to embark on the more demanding stages of professional growth.

In conclusion, the early years of an actor's life—shaped by family, play, exposure to the arts, and formal training—establish the groundwork for a career defined by both craft and character. Childhood experiences cultivate empathy and creativity; early stage work teaches discipline, collaboration, and the nuances of performance; and lessons learned from failure, mentorship, and pivotal moments instill resilience and self-awareness. These formative experiences are not merely preparatory; they are foundational. They remind us that the making of an actor is as much about personal growth as it is about artistic skill. The seeds planted in these years—through curiosity, experimentation, guidance, and reflection—blossom into a lifelong engagement with the transformative power of performance.

As the actor moves forward, stepping onto larger stages and embracing more complex roles, the echoes of these early years remain ever-present. The memories of first applause, first missteps,

and first mentors continue to inform every choice, every performance, and every artistic endeavor. The journey from childhood fascination to professional mastery is neither simple nor predictable, but it is profoundly shaped by the experiences, lessons, and relationships of these formative years. It is within this rich tapestry of early encounters, training, and reflection that the true essence of the actor begins to emerge—a blend of imagination, skill, and humanity that will continue to evolve throughout a lifetime dedicated to the craft.

Chapter 2: The Craft of a Lifetime

The life of an actor is one of constant evolution, a journey defined not only by the roles one inhabits but also by the relentless pursuit of understanding the human experience. Acting is more than memorizing lines or hitting marks; it is an intricate interplay of mind, body, and emotion. Each performance requires a unique alchemy of preparation, instinct, and insight, and it is this fusion that separates fleeting appearances from enduring art. In this chapter, we explore the depth of the actor's craft, the nuances of character creation, the delicate balance of discipline and intuition, and reflections on some of the most iconic performances that define a lifetime in the theater and cinema.

SECTION 1: Character and Transformation – Understanding Roles and Empathy

At the heart of acting lies a profound commitment to transformation. The actor's task is not merely to portray a character but to inhabit them fully, to become a vessel through which the audience glimpses a life not their own. This process begins with empathy. Understanding a character means stepping into their world—seeing through their eyes, feeling their fears, and embracing their desires. Empathy is not an optional tool; it is the cornerstone of authentic performance. Without it, a role risks remaining superficial, a costume without a soul.

Consider, for instance, the process of embodying a character whose life circumstances diverge dramatically from the actor's own. It requires research, observation, and a willingness to confront uncomfortable truths. Actors often study history, psychology, or sociology to understand the societal and personal forces shaping their characters. They observe human behavior in everyday life, noting the subtleties of gesture, tone, and posture that reveal inner states. Transformation is

both outward and inward: physicality and voice must align with emotional truth. One cannot convincingly play grief without first understanding its many dimensions—the quiet resignation, the explosive outbursts, the invisible burdens that weigh on the body and mind.

The notion of transformation extends beyond mere imitation. Great actors internalize the essence of their characters, allowing these fictional lives to inform their own emotional landscape. This can be a double-edged sword; the deeper the immersion, the greater the potential for personal resonance, and sometimes, vulnerability. Method acting, popularized in the twentieth century, exemplifies this approach. It demands not only study but lived experience, urging actors to recall their own memories and emotions to fuel authentic reactions. While method acting is not universally embraced, it underscores the principle that effective performance relies on genuine connection—an intimacy between actor and role that transcends artifice.

Empathy in acting is also a social skill, one that extends to relationships with other actors and the ensemble. No performance exists in isolation; it is a dynamic exchange between individuals sharing a narrative space. Understanding a character fully includes understanding how that character interacts with others—the tensions, affections, and power dynamics that drive narrative conflict. A scene may hinge not on what a character says but on what they withhold, on the unspoken currents of emotion flowing between performers. Actors who cultivate empathy learn to listen and respond authentically, to inhabit their own role while simultaneously honoring the roles of others.

Transformation requires patience. Developing a character is rarely immediate; it unfolds over rehearsals, conversations with directors, and repeated experimentation. The actor must be willing to explore multiple dimensions, testing interpretations, discarding what does not resonate, and discovering the layers that reveal complexity and truth. A character may begin as a sketch, a collection of traits and background details, but through diligent exploration, they emerge as a living, breathing entity. This journey mirrors the human experience: just as individuals evolve through circumstance, choice, and reflection, so too must characters develop organically within their narrative worlds.

An actor's ability to transform is not limited to extremes or dramatic departures from self. Often, the challenge lies in subtlety—portraying the mundane with profound authenticity. A glance, a sigh, a hesitation can convey as much meaning as a climactic monologue. The mastery of nuance distinguishes performances that linger in memory from those that fade quickly. Empathy enables these subtleties to shine, as the actor senses the internal rhythms of their character, allowing them to manifest naturally on screen or stage.

Finally, transformation is a lifelong pursuit. No actor ever completes it fully, for human behavior and psychology are endlessly complex. Each role presents new challenges, new moral dilemmas, and new emotional territories to explore. It is this continual striving for understanding, this dedication to the craft as a path of empathy and insight, that defines a career not merely of performances but of artistry.

SECTION 2: Technique and Instinct – Balancing Discipline with Spontaneity

While empathy and transformation form the emotional core of acting, technique provides the structural foundation. Acting is a discipline as much as an art, and it is the mastery of technical skills that allows an actor to translate emotional insight into effective performance. Voice control, physical expressiveness, timing, and memorization are all elements that must be honed through deliberate practice. Without this technical groundwork, emotional authenticity alone may falter, leaving the performance ungrounded or inconsistent.

Technique begins with understanding the body and voice as instruments. Every movement, gesture, and intonation carries meaning. Posture can communicate confidence or vulnerability; a slight tilt of the head or shift in weight can reveal hesitation or resolve. Similarly, the voice conveys far more than words alone. Rhythm, pitch, and modulation provide subtle cues to a character's internal state, and mastery of these elements allows actors to deliver lines with precision and emotional resonance. Many actors undergo extensive training in voice, speech, and

movement, often drawing from practices such as Alexander Technique, stage combat, or physical theater to refine their control and expressiveness.

Yet technique, while essential, is only half the equation. Acting also demands instinct—the spontaneous, intuitive responses that breathe life into a performance. No script can anticipate every nuance of human behavior, and no rehearsal can capture the immediacy of a moment fully. Here, instinct becomes the actor's compass, guiding reactions and choices in real time. It is what allows a performer to seize the unexpected, to respond truthfully to a scene partner, and to inhabit a character's present with authenticity. The challenge lies in balancing technique and instinct, structure and freedom, planning and improvisation.

This balance is often evident in rehearsal processes. A well-prepared actor uses technical knowledge to establish the framework of a scene—beats, motivations, and objectives—while remaining open to discovery. Rehearsals become laboratories for experimentation, where choices are tested, discarded, and refined. Within this disciplined environment, instinct flourishes. The actor learns when to rely on rehearsed precision and when to surrender to the organic flow of interaction. It is this interplay that produces performances that are both technically sound and emotionally compelling.

Discipline is also crucial in sustaining the physical and mental demands of the profession. Long hours, repeated takes, and the intensity of live performance require stamina and resilience. Actors develop routines that preserve their energy, strengthen their vocal and physical capabilities, and maintain focus. Yet discipline should not become rigidity; the finest performances emerge when structure supports creativity rather than constraining it. The most compelling actors are those who can navigate the tension between preparation and presence, allowing technique to serve instinct rather than dominate it.

Instinctive acting is often most visible in moments of improvisation, whether scripted or spontaneous. An actor's capacity to inhabit a character fully allows for improvisational flourishes that feel authentic and grounded. Even when lines are predetermined, the timing, rhythm, and subtle variations in delivery can transform a scene from functional to unforgettable.

Directors and actors alike recognize the magic that occurs when disciplined preparation meets intuitive responsiveness—a synergy that elevates acting from craft to artistry.

Moreover, instinct and technique interact with audience perception. A technically perfect performance that lacks spontaneity may feel stiff or artificial. Conversely, raw instinct without technical grounding risks incoherence. The actor's challenge is to integrate these elements seamlessly, crafting a performance that is precise yet alive, calculated yet spontaneous. This integration is an ongoing endeavor, refined through experience, reflection, and a willingness to experiment and learn from both successes and failures.

Ultimately, the actor's craft is a delicate equilibrium. Mastery requires a commitment to lifelong study, an openness to instinct, and a disciplined approach to skill development. When these forces align, the result is a performance that resonates on multiple levels—emotionally, intellectually, and aesthetically—inviting the audience into a world that is at once believable and extraordinary.

SECTION 3: Iconic Performances – Reflections on Memorable Roles

No discussion of an actor's craft would be complete without examining the roles that define a career. Iconic performances are not merely displays of talent; they are moments when preparation, instinct, empathy, and technical skill converge to create something enduring. These roles become touchstones in cultural memory, shaping both the public's perception of the actor and the evolution of the craft itself.

Iconic performances often emerge from roles that demand transformation on multiple levels. Consider characters whose moral ambiguity, psychological complexity, or emotional intensity challenges the actor to go beyond conventional portrayals. The best performances reveal layers of humanity, exploring contradictions, vulnerabilities, and resilience. Audiences are drawn to these portrayals because they recognize truth in fiction—the reflection of their own experiences,

fears, and desires. The actor becomes a conduit for universal themes, and the role transcends the screen or stage to leave a lasting imprint.

Reflection on memorable roles also highlights the actor's relationship with risk. Iconic performances frequently require stepping outside comfort zones, confronting personal insecurities, or embracing challenging subject matter. Risk-taking is intrinsic to the pursuit of excellence in acting; without it, performances may remain safe, predictable, and ultimately forgettable. Courage, both artistic and personal, allows actors to inhabit characters fully, to make choices that resonate deeply, and to leave an indelible mark on audiences.

The impact of iconic roles is magnified by the collaborative nature of performance. Directors, writers, fellow actors, and production teams all contribute to the creation of a character's world. An actor's ability to engage authentically with these collaborators enhances the richness of the performance. Iconic moments often arise not from solitary brilliance but from the interplay of multiple creative forces, each adding nuance and depth. The actor's sensitivity to these dynamics—attuned to timing, chemistry, and emotional resonance—is as important as their individual skill.

Audience reception also plays a role in defining iconic performances. While critical acclaim may validate technique and execution, the lasting power of a performance often rests in its emotional resonance with viewers. When a portrayal captures the essence of a character in a way that speaks across time, culture, and context, it achieves immortality in the collective imagination. These performances influence generations of actors, inform cultural dialogue, and redefine expectations for what is possible in storytelling.

Finally, reflection on memorable roles offers insight into the evolution of the actor's craft itself. Each significant performance is a milestone, marking growth, experimentation, and discovery. Actors often look back on these roles not merely as achievements but as learning experiences, opportunities to refine their understanding of character, technique, and instinct. The legacy of iconic performances is therefore dual: they impact audiences in the present while guiding the actor's continued development and shaping the future of the craft.

Whether through dramatic triumphs, subtle character studies, or transformative improvisation, iconic roles exemplify the culmination of empathy, technique, and instinct. They remind us that acting is both an art and a discipline, a vocation that demands courage, insight, and unrelenting dedication. For actors, these performances are benchmarks, reflecting the heights of possibility within the craft and inspiring the next generation to pursue excellence with passion and integrity.

Conclusion

The craft of acting is a lifelong journey, marked by continual transformation, rigorous discipline, and intuitive insight. Understanding character through empathy, balancing technical skill with instinct, and embracing the challenge of iconic roles all define the path of an actor dedicated to the pursuit of truth in performance. Acting is more than a profession; it is a commitment to explore the human experience, to reflect its complexities with honesty and creativity, and to leave an enduring impact on audiences across generations.

In this chapter, we have traced the interwoven threads of character, technique, and memorable performance, revealing how they converge to create art that resonates. The actor's craft is at once demanding and exhilarating, structured yet spontaneous, deeply personal yet profoundly collaborative. It is a craft honed over decades, a labor of love that embodies the transformative power of storytelling and the timeless beauty of human connection.

Chapter 3: Art in Context

SECTION 1: Film, Theater, and Beyond – The Mediums That Shaped Him

Art, in its myriad forms, is never created in isolation. For an actor of remarkable depth and versatility, each medium offers not just a stage but a unique universe with its own rules, challenges, and possibilities. In the case of the subject of this chapter, his artistic journey was shaped profoundly by his engagement across multiple platforms—film, theater, and beyond—each medium leaving an indelible mark on his craft. Understanding the interplay of these environments is crucial for appreciating the full scope of his artistic evolution.

Theater, often considered the birthplace of disciplined acting, provided him with a foundation of rigor, timing, and presence. Unlike film, where a single scene can be shot multiple times and edited to perfection, theater demands a sustained, living performance. It requires the actor to inhabit the character continuously, from the first line to the final curtain. In this environment, the actor learns not only technical skills—voice projection, physicality, and timing—but also the subtle art of immediacy. Theater cultivates a heightened sensitivity to the audience's reactions, teaching the actor to modulate energy and emotion in real time. For him, the theater was both a laboratory and a proving ground. Roles were not merely performances but exercises in resilience, endurance, and empathy.

Film, by contrast, introduced him to the nuances of subtlety and internalization. The camera, with its ability to capture the slightest flicker of an eye or the smallest tension in a hand, rewards restraint and minute detail. Film acting requires the discipline of patience: waiting for cues, hitting marks with precision, and performing the same sequence under slightly different conditions while maintaining emotional continuity. In front of the lens, the actor learns to convey depth without overt exposition. Every gesture and inflection becomes magnified, every pause

weighted with meaning. His immersion in film allowed him to refine a language of subtlety and inner truth that would inform all subsequent performances.

Beyond theater and film, other forms of expression, such as radio, voiceover work, and experimental performance, contributed layers to his craft. Voice acting, for instance, emphasizes the musicality of language and the expressive potential of tone, cadence, and silence. Experimental performances—whether immersive theater, avant-garde productions, or short-form projects—challenge conventional notions of storytelling, pushing actors to rethink the boundaries of character and narrative. Each medium demands adaptation, flexibility, and a willingness to embrace uncertainty, qualities that became hallmarks of his career.

His work across these mediums was not merely a series of professional milestones; it was an ongoing dialogue between different artistic philosophies. Theater demanded courage and projection, film required intimacy and precision, and experimental forms nurtured curiosity and innovation. The synthesis of these experiences fostered a versatility that allowed him to inhabit characters fully and authentically, regardless of the platform. More importantly, this multidimensional approach to acting cultivated a profound understanding of human behavior, motivation, and emotion—a sensibility that would resonate throughout his later work.

At the core of his artistic development was an understanding that each medium is not just a technical challenge but a philosophical one. Theater teaches temporality and presence, film teaches perception and observation, and experimental forms teach exploration and risk. By traversing these landscapes, he developed a nuanced appreciation of the interplay between form and content, structure and improvisation, discipline and instinct. His ability to adapt to the demands of each medium without losing the essence of his performance was a testament to both his craft and his insight into the nature of storytelling itself.

SECTION 2: Collaboration – Working with Directors, Co-actors, and Creative Teams

No actor exists in a vacuum. While talent and technique are essential, it is the collaborative process that transforms isolated skill into a resonant performance. Throughout his career, he

demonstrated an extraordinary capacity to engage with directors, co-actors, and the broader creative team, embracing collaboration not as compromise but as a conduit for greater artistry.

Directors, often seen as the architects of a production, played a pivotal role in shaping his performances. Each director brings a unique vision, a particular rhythm, and a philosophical approach to storytelling. For the actor, understanding and internalizing this vision is both a challenge and an opportunity. He exhibited a remarkable ability to absorb directorial intent without losing his own interpretive voice. Whether the director favored strict technical precision or a more organic, improvisational approach, he could adapt seamlessly, enhancing the director's vision while contributing his own insights. This balance of obedience and creativity became a defining feature of his professional ethos.

Collaboration with co-actors was equally vital. Acting, especially in ensemble settings, is a conversation—both literal and figurative. The energy, timing, and choices of one performer influence and are influenced by those around them. He possessed an acute sensitivity to the rhythms of other actors, able to anticipate and respond with authenticity and nuance. This reciprocity is particularly evident in scenes of intense emotion or conflict, where the interaction between actors becomes a crucible for spontaneity and truth. His co-actors often noted his generosity on stage and screen: a readiness to share space, to listen, and to support the emotional arc of the scene. Such generosity not only elevated the immediate performance but also fostered trust, camaraderie, and creative risk-taking.

The broader creative team—set designers, costume designers, cinematographers, lighting technicians, and sound engineers—also contributed to the actor's understanding of the collaborative ecosystem. He approached these relationships with curiosity and respect, recognizing that each element, no matter how technical or peripheral, shapes the audience's experience. He would often spend time discussing costume choices with designers, considering how clothing could inform character and movement. He would collaborate with cinematographers to understand how lighting and framing might influence subtle gestures or facial expressions. This holistic approach exemplified an awareness that acting is not an isolated art form but a node in a network of creative forces, each integral to storytelling.

Importantly, his approach to collaboration was characterized by humility and adaptability. He understood that ego and rigid control often undermine creative potential. By prioritizing the story and the integrity of the performance over personal recognition, he cultivated an environment where experimentation and authenticity could flourish. Directors trusted him not only to execute instructions but to enrich the narrative with his instincts. Co-actors found a partner who elevated scenes rather than competing for attention. And the creative team experienced an artist who valued their contributions, fostering mutual respect and shared purpose.

Collaboration also required emotional intelligence. The pressure of production schedules, creative disagreements, and high expectations can create tension and conflict. His ability to navigate these dynamics with patience, tact, and empathy allowed him to maintain focus on the work while nurturing professional relationships. Over time, this collaborative acumen became a hallmark of his reputation, attracting both established directors and emerging talent eager to work with someone who could bring cohesion, insight, and energy to any project.

Ultimately, his commitment to collaboration reflects a profound understanding of the nature of art itself. Acting is not merely about individual expression; it is about creating a living, breathing experience that resonates with audiences. By engaging deeply with every collaborator—from director to lighting technician—he ensured that each performance was not just a personal achievement but a collective triumph, where multiple visions converged to form a cohesive, impactful whole.

SECTION 3: Influence and Inspiration – How His Work Resonates Across Generations

An artist's true measure is not simply the accolades they receive but the ways in which their work transcends time, medium, and culture. In the case of this actor, his performances have left an enduring imprint on audiences, peers, and subsequent generations of artists. Understanding the mechanisms of this influence requires an examination of both the craft itself and the context in which it operates.

First, the authenticity and depth of his performances have set a benchmark for aspiring actors. He did not rely on superficial gestures or clichéd expressions; instead, he approached each character with meticulous preparation, empathy, and emotional truth. By immersing himself fully in the psychological and emotional landscape of his roles, he created performances that felt lived-in, genuine, and compelling. For emerging actors, this commitment serves as a model of dedication and integrity, demonstrating the transformative power of rigorous preparation and imaginative empathy.

Second, his willingness to traverse diverse roles and genres has expanded the boundaries of performance. From dramatic tragedies to subtle comedies, historical epics to intimate character studies, his versatility has shown that excellence in acting is not confined to a particular niche. This diversity has inspired other actors to pursue breadth as well as depth, cultivating a profession in which risk-taking and experimentation are valued alongside technical skill. By refusing to be pigeonholed, he exemplified an artistic courage that continues to influence career trajectories and creative choices across generations.

Third, his work resonates because it engages universal human experiences—fear, desire, longing, moral conflict, and resilience. The emotional truths embedded in his performances transcend cultural and temporal boundaries, allowing audiences from different backgrounds to connect with the characters he inhabits. This universality amplifies his influence, ensuring that his artistry remains relevant and meaningful long after the initial release of a film or the final curtain of a stage production. Scholars, critics, and fans alike study and celebrate his work, recognizing its capacity to evoke introspection, empathy, and emotional engagement.

Moreover, his influence extends beyond performance technique. He has inspired conversations about the role of art in society, the ethics of storytelling, and the responsibilities of artists as cultural participants. By choosing projects that challenge societal norms, illuminate marginalized perspectives, or provoke critical reflection, he demonstrated that art can be both beautiful and consequential. This ethical dimension of his career has encouraged other artists to consider not only the aesthetics of their work but also its impact on the audience, the community, and the cultural landscape at large.

Another dimension of his influence is mentorship. Throughout his career, he actively engaged with younger actors, sharing insights, providing guidance, and fostering an environment where curiosity and risk-taking were encouraged. These acts of mentorship, often informal yet profoundly impactful, have propagated his artistic philosophy, ensuring that his approach to craft, collaboration, and integrity continues to shape the next generation of performers. The ripple effects of his mentorship underscore a crucial point: influence is not limited to public recognition but is also embedded in the quiet, sustained transmission of knowledge, values, and inspiration.

Finally, his legacy highlights the interplay between consistency and evolution. While he maintained core principles of preparation, authenticity, and collaboration, he continually adapted to new forms, technologies, and cultural shifts. This ability to evolve while remaining grounded in foundational values makes his work a living source of inspiration. Audiences, critics, and peers are drawn not only to the brilliance of individual performances but also to the arc of an artistic journey characterized by growth, reflection, and resilience.

In sum, his influence is multifaceted. It operates at the level of craft, ethical engagement, mentorship, and cultural resonance. Through the combination of technical mastery, collaborative spirit, emotional depth, and commitment to meaningful storytelling, he has created a body of work that continues to inspire, challenge, and enrich the artistic community. The lessons embedded in his career are both timeless and dynamic, providing a blueprint for aspiring artists while affirming the enduring power of authentic, heartfelt performance.

Conclusion

Art in context is never static; it is an evolving dialogue between medium, collaboration, and influence. For this actor, each medium provided a unique set of challenges and opportunities that shaped his approach to performance. Theater honed presence and resilience, film refined subtlety and observation, and experimental work nurtured curiosity and innovation. Collaboration with directors, co-actors, and creative teams further refined his craft, demonstrating that artistry is a

shared, communal endeavor. Finally, the resonance of his work across generations illustrates the enduring power of authenticity, versatility, and ethical engagement.

By examining his career through these interconnected lenses, we gain not only a richer understanding of his artistry but also insight into the broader nature of performance itself. Acting, in its highest form, is a synthesis of skill, empathy, and vision—a medium through which human experience is interpreted, illuminated, and shared. His work embodies this synthesis, offering a model of what it means to create with intention, intelligence, and heart. Across mediums, collaborations, and generations, his legacy underscores a simple yet profound truth: art is at once personal and collective, fleeting and timeless, a mirror to our own humanity.

Chapter 4: Aging, Perspective, and Grace

SECTION 1: Time and Transformation – Aging as an Actor and Human Being

Time is a curious companion. It slips past with an almost imperceptible rhythm, yet leaves its imprint on every aspect of our lives. For actors, the passage of time is particularly intimate; it is both a friend and a formidable mentor. To watch oneself age on stage and screen is to confront, repeatedly, the inexorable reality that change is the only constant. This transformation is not merely physical—it is profoundly internal, affecting the lens through which one views the world, art, and oneself. As an actor, every line spoken, every emotion conveyed, is filtered through the evolving framework of age and life experience. Roles that once seemed distant or unattainable take on new meaning, enriched by lived experience and deeper emotional resonance.

The physical aspects of aging are often the first markers. Wrinkles, grey hair, subtle changes in posture, and shifts in energy levels become daily reminders of life's impermanence. Yet, beyond these surface-level changes, aging reshapes the inner landscape of an actor. There is a maturing of instinct, a refinement of craft, and a recalibration of priorities. The brashness of youth, once a source of raw energy and daring choices, slowly gives way to discernment. Each decision—be it a role choice, a method of preparation, or a collaborative approach—carries the weight of accumulated wisdom. This is a gift time offers, though one that demands acknowledgment: the acceptance that some opportunities fade while others, previously overlooked, now become attainable through a richer, more nuanced understanding of the human condition.

Aging also deepens the capacity for empathy. An actor's ability to inhabit a character is invariably intertwined with their understanding of life's complexities. As one moves through decades, experiences of love, loss, triumph, and regret expand emotional bandwidth, enabling a performer to portray roles with greater authenticity and subtlety. The vulnerabilities of youth,

once raw and untempered, transform into a measured insight that allows for an honest and profound connection with the audience. Time, therefore, is both a sculptor and a lens: it shapes the actor while simultaneously refining the art itself.

Yet the journey is not devoid of challenge. Age in an industry that prizes youth and novelty can impose external pressures. Society often equates vibrancy with youth, overlooking the profound contributions of those whose depth is derived from years. Navigating these pressures requires resilience, self-awareness, and the grace to redefine one's own standards of success. It is an exercise in self-preservation and artistic integrity: understanding that the value of one's work does not diminish with the years, but rather transforms in its scope and impact. Indeed, aging encourages a reassessment of priorities—choices become less about public validation and more about personal fulfillment, artistic honesty, and meaningful connection.

On a personal level, aging shapes identity in subtle ways. The actor may find that the persona presented to the world—the public image cultivated over years—must evolve to align with a more authentic self. There is freedom in this evolution: the chance to embrace complexity, imperfections, and the richness of lived experience without the constant pressure of external expectation. Aging, in this sense, becomes not a limitation but an expansion: a widening of perspective that allows for a fuller engagement with both art and life.

Transformation through time is also evident in the ways actors interact with their craft. Early in a career, technical mastery, memorization, and the pursuit of recognition often dominate attention. With maturity, however, there is a shift toward resonance: the desire to communicate truth, to evoke emotion, and to engage deeply with both the material and the audience. Roles once chosen for their glamour or challenge may be reconsidered in favor of parts that offer complexity, humanity, and enduring significance. Time, therefore, is both teacher and catalyst: it illuminates what matters most and clarifies the path toward meaningful artistry.

In summary, aging for an actor is a multifaceted journey. It is a process of physical, emotional, and psychological transformation, intertwined with the evolving understanding of art and humanity. It is an invitation to deepen empathy, refine craft, and embrace the shifting definitions of success and fulfillment. The challenges of external perception may persist, but within lies the

opportunity for authenticity, resilience, and a richer, more profound connection to both the audience and oneself. Time, in its relentless progression, is not merely a measure of years but a sculptor of identity, a reservoir of wisdom, and a canvas upon which the most meaningful work can unfold.

SECTION 2: Reflection and Acceptance – Facing Choices, Mistakes, and Triumphs

Reflection is a cornerstone of aging. To look back upon one's life and career is to confront an intricate tapestry of choices, mistakes, and triumphs. This process can be both humbling and illuminating. It requires honesty, courage, and the willingness to embrace the entirety of one's experience without denial or self-deception. For an actor, reflection is intimately tied to craft: the roles selected, the performances delivered, and the relationships forged within the industry are all facets of a broader narrative that shapes identity, artistry, and legacy.

Mistakes, in particular, occupy a crucial role in the reflective process. No life is exempt from missteps, missed opportunities, or moments of regret. Yet these instances are not merely setbacks—they are lessons embedded within the architecture of experience. The choices that once seemed catastrophic or misguided often reveal themselves, in hindsight, as essential catalysts for growth. In acting, as in life, failure can be a powerful teacher. A role turned down, a performance poorly received, or a relationship strained may initially appear as loss, but with time, these events provide insight into priorities, resilience, and the capacity for renewal. Accepting mistakes, rather than dwelling in self-reproach, allows one to integrate them into a broader narrative of personal and professional development.

Triumphs, conversely, offer validation and encouragement. They are milestones that punctuate the journey, marking moments when effort, dedication, and talent converge to create something meaningful. These successes—be they acclaimed performances, recognition from peers, or personal achievements—serve as reminders of one's capacity to contribute, inspire, and evolve. Yet triumphs, too, require reflection: the most meaningful victories are often those that transcend

external validation, resonating instead with personal values, integrity, and the impact on others. In this light, success becomes less about accolades and more about alignment with one's authentic self.

Acceptance emerges as the natural counterpart to reflection. To age gracefully is to confront reality without resentment or illusion, acknowledging both limitations and strengths. It is the recognition that life is composed of a mosaic of experiences, each contributing to the whole. In acting, this acceptance allows performers to embrace roles that suit their current stage of life, to relinquish attachment to past ideals, and to engage with their craft with a clarity born of experience. Acceptance also fosters empathy and humility: the awareness that everyone is navigating their own journey, shaped by choices, circumstances, and opportunities, encourages compassion both on and off the stage.

Reflection and acceptance are also deeply intertwined with relationships. Over time, the bonds formed with colleagues, mentors, and collaborators gain nuance and depth. Conflicts and misunderstandings, once sources of frustration, are reframed within a broader context of growth and mutual understanding. Successes shared with others acquire a resonance that surpasses individual achievement, highlighting the communal nature of artistic endeavor. The process of reflection thus enriches not only self-perception but also interpersonal connections, fostering gratitude, forgiveness, and a more profound appreciation for the human tapestry within which one operates.

Furthermore, reflection offers perspective on the passage of time itself. Early career ambitions, once urgent and consuming, are reconsidered in light of accumulated experience. What once seemed paramount may diminish in significance, while previously undervalued aspects of life gain prominence. This recalibration is not passive—it is an active engagement with priorities, values, and aspirations. The capacity to step back, assess, and adjust course is a hallmark of maturity, allowing one to navigate life with intentionality and grace rather than reaction and anxiety.

In practice, reflection can take many forms. Journaling, conversations with trusted confidants, and quiet contemplation all serve as avenues for processing experience. For actors, analyzing

past performances, revisiting pivotal roles, and considering the evolution of artistic choices provides not only professional insight but also personal clarity. Reflection becomes both a mirror and a guide: it illuminates past decisions while charting the path forward, fostering a sense of coherence, continuity, and purpose.

Ultimately, the intertwining of reflection and acceptance creates a foundation for resilience and wisdom. By facing choices, mistakes, and triumphs with honesty and compassion, one cultivates a mindset capable of navigating the complexities of both art and life. Aging, in this light, is not a passive progression but an active, conscious engagement with the entirety of experience, a process that transforms challenges into insight, regrets into lessons, and achievements into enduring sources of fulfillment.

SECTION 3: The Wisdom of Experience – Sharing Knowledge and Leaving a Legacy

Wisdom is perhaps the most profound gift of time. Unlike skill or talent, which can be acquired and honed, wisdom emerges through the integration of lived experience, reflection, and insight. For those who have navigated decades of life and work, there exists a responsibility—and an opportunity—to share this accumulated knowledge, offering guidance, inspiration, and perspective to others. The act of imparting wisdom is both selfless and generative: it extends the impact of one's experience beyond personal confines, contributing to the enrichment of community, art, and culture.

In the realm of acting, wisdom manifests in many forms. Mentorship, for instance, is a direct channel through which seasoned actors can guide emerging talent. Sharing lessons learned from triumphs and setbacks, offering technical advice, and modeling professional integrity cultivates the next generation of performers. This process is mutually enriching: teaching and mentoring reinforce one's own understanding, prompting reflection on the nuances of craft, the ethics of collaboration, and the essence of authentic expression. Wisdom, therefore, is not static; it evolves

and deepens as it is communicated, creating a dynamic interplay between experience and influence.

Beyond formal mentorship, wisdom is conveyed through storytelling. Actors possess a unique vantage point, having inhabited myriad lives and perspectives. Recounting these experiences, whether through interviews, memoirs, or casual conversation, offers insights into human nature, resilience, and creativity. Stories of struggle, perseverance, and discovery resonate across generations, providing both cautionary tales and sources of inspiration. By articulating the lessons embedded in these narratives, one transforms personal history into collective knowledge, ensuring that experience is not lost to the passage of time but actively contributes to the growth of others.

Leaving a legacy encompasses more than the transfer of technical skill; it includes the transmission of values, principles, and ethos. The ethical and artistic choices made over a lifetime—how one navigates success and failure, treats colleagues, and responds to challenges—become integral elements of legacy. Legacy is not solely defined by public acclaim or awards, but by the enduring influence of character, wisdom, and example. In this sense, every interaction, decision, and performance contributes to the mosaic of impact that outlives the individual.

Equally important is the cultivation of a reflective, intentional approach to legacy. To leave a meaningful imprint requires self-awareness, deliberation, and a conscious alignment between actions and values. It is an acknowledgment that the knowledge and insights accumulated through life have the power to shape futures, inspire courage, and enrich understanding. For actors, this means considering not only the art they create but also the manner in which they engage with peers, the mentorship they provide, and the ethical stance they uphold within an industry often fraught with compromise.

Sharing wisdom and leaving a legacy also carries a profound emotional dimension. There is satisfaction in knowing that one's life, choices, and experiences have contributed positively to others. There is solace in recognizing that the journey, with all its triumphs and trials, has created ripples beyond the self. This awareness fosters a sense of completeness and continuity, a bridge

between past, present, and future. In essence, wisdom becomes a conduit for transcendence, connecting the finite nature of individual experience with the enduring flow of human endeavor.

Moreover, the act of legacy-building reinforces a sense of purpose in later life. As actors age and opportunities for performance change, the focus naturally shifts from personal recognition to generativity—the desire to cultivate, inspire, and uplift. This shift reflects a profound understanding: that life's ultimate measure is not the accumulation of accolades, but the quality of influence, the depth of relationships, and the positive impact imparted upon others. The wisdom of experience, therefore, is not merely a private treasure; it is a shared resource, an offering to the ongoing narrative of human creativity, resilience, and compassion.

In conclusion, the wisdom gained through decades of life and artistic endeavor is a multifaceted treasure. It encompasses the technical, ethical, emotional, and philosophical dimensions of experience, offering guidance and inspiration to others. Sharing this wisdom and cultivating a thoughtful legacy transforms personal history into communal enrichment, ensuring that the lessons of time endure. Through mentorship, storytelling, ethical example, and intentional reflection, the seasoned actor not only enhances the craft but also contributes meaningfully to the broader human story, leaving behind a legacy that resonates long after the final curtain has fallen.

Conclusion

Aging, perspective, and grace are intertwined in a dance of time, reflection, and wisdom. The process of aging, far from being a decline, represents transformation—an evolution of identity, craft, and understanding. Reflection and acceptance allow one to confront the totality of life, integrating choices, mistakes, and triumphs into a coherent, meaningful narrative. And the wisdom accrued across years becomes a gift: a resource to guide, inspire, and shape future generations.

To age with grace is to embrace change, to cultivate empathy, to reflect honestly, and to share generously. It is a journey of continuous learning and giving, a recognition that life's value is measured not by mere longevity or achievement, but by the depth of understanding, the integrity of action, and the resonance of influence. In this light, aging is neither a loss nor a limitation; it is a profound opportunity for growth, contribution, and the enduring celebration of the human spirit.

Chapter 5: Looking Back, Moving Forward

SECTION 1: Memoirs and Musings – Personal Insights Beyond the Screen

Looking back often comes with a quiet sense of surprise. We rarely recognize in the moment how ordinary moments, fleeting decisions, and unnoticed choices accumulate to define the narrative of our lives. In the realm of acting and creativity, this becomes particularly salient. Life itself is inseparable from the art we create, and the reflections that emerge from both spheres offer profound insights that go far beyond the confines of a screen or stage.

Memoirs, by their nature, are invitations. They invite the reader into a life seen through a particular lens, a lens shaped by experiences, triumphs, failures, and the private moments that usually remain hidden. They are not merely a catalog of achievements; they are a dialogue with oneself and with the audience, bridging the inner life and the outer world. Writing or even contemplating a memoir forces a kind of reconciliation—a confrontation with the person we were, the choices we made, and the consequences we sometimes still carry. This reflection is not always comfortable. It can reveal regrets, unresolved conflicts, or missed opportunities. Yet, these same reflections offer clarity. They illuminate patterns, reveal recurring themes, and highlight the values that have anchored us despite the inevitable chaos of life.

For someone whose life is public, whose work is constantly observed and critiqued, memoirs offer a chance for reclamation. They allow the individual to articulate personal truths without the distortion of media narratives or public perception. They are a platform to assert agency over one's story, to explain the nuance behind decisions, and to share the intimate reflections that often remain unspoken.

Beyond the public sphere, personal musings—whether written in journals, letters, or simply pondered in quiet solitude—serve a similar function. They allow a deep processing of life's

events, fostering both understanding and acceptance. In these contemplative spaces, one can explore questions that no one else can answer: How did certain experiences shape me? What did I truly want at the time? How have my priorities evolved? These musings are not exercises in self-indulgence; they are essential acts of self-clarity. They connect the dots between disparate experiences and reveal the broader narrative of a life lived with intention, curiosity, and emotional depth.

An important aspect of these reflections is the acknowledgment of impermanence. Life, much like art, is transient. Roles end, performances fade from memory, and moments pass before they can be fully grasped. In memoirs, the ephemeral nature of time is captured, reminding us that while the past cannot be relived, it can be understood and honored. Insights gained from reflection provide guidance for the present and inspiration for the future. They allow us to approach life with a sense of continuity, recognizing that every action, every decision, and every moment of connection contributes to an evolving narrative that extends far beyond the immediate.

Furthermore, memoirs and musings cultivate empathy. By reflecting deeply on one's own experiences, one begins to recognize the shared human condition—the struggles, joys, and contradictions that link us all. This realization enriches interactions with others, both on and off the screen, and fosters a sense of interconnectedness that transcends the boundaries of profession, status, or circumstance. Life viewed through this reflective lens is not just a sequence of events; it becomes a rich tapestry woven with meaning, emotion, and understanding.

Ultimately, personal insights gained through memoirs and musings are tools for self-liberation. They allow individuals to step outside the roles they play—both literally and figuratively—and confront the essence of who they are. In doing so, they create a space for authenticity, courage, and profound self-awareness. The journey of looking back, in this sense, is never purely retrospective; it is also forward-facing, equipping us to engage with life in a more deliberate, intentional, and meaningful way.

SECTION 2: The Intersection of Life and Art – What We Carry Forward

Art and life are inextricably intertwined, each reflecting and informing the other. For those who dedicate themselves to creative expression, the lessons drawn from personal experiences often become the fuel for artistic endeavor. Likewise, the art we create leaves an imprint on the way we understand ourselves, the world, and our place within it. This intersection of life and art is both inevitable and transformative, shaping our identity and providing a lens through which to interpret the unfolding of our days.

In acting, as in many creative professions, one learns early that the most compelling performances arise not from technique alone but from the authenticity of lived experience. Every emotion we portray is informed by moments of vulnerability we have faced, decisions we have made, and relationships that have defined us. Pain, joy, confusion, triumph, and loss—all of these elements of life enrich our capacity to inhabit characters with truth and depth. The actor becomes a conduit, channeling personal understanding into performance, translating private experiences into universal expression.

Yet this process is reciprocal. The act of engaging with art—performing, creating, or interpreting—also reshapes our perspective on life. Roles and projects often require exploring dimensions of the human condition that we might never confront in ordinary circumstances. Empathy is cultivated as we inhabit the lives of others; patience and resilience grow as we navigate the demands of collaboration, discipline, and repetition. Through art, we are repeatedly reminded of the complexity, fragility, and beauty of existence.

The intersection of life and art is perhaps most apparent in the moments of profound reflection that follow a project's completion. Watching a performance, reading a completed script, or reviewing a piece of work allows us to step back and see the imprint of our own experiences in the creation. It is in these moments that we recognize the continuity between what we have lived and what we have produced. The roles we choose, the stories we tell, and the themes we explore often reveal as much about our internal landscape as they do about the external world.

One of the most compelling aspects of this intersection is the legacy it produces. Art carries forward fragments of our understanding, our questions, and our insights long after the immediate moment has passed. A performance, a film, a piece of writing—it continues to influence, inspire,

and challenge audiences. In this way, art becomes a vessel for memory, reflection, and continuity. It immortalizes the essence of our engagement with life, offering future generations the opportunity to witness, interpret, and learn from the experiences that shaped us.

Moreover, this interplay encourages mindfulness and intentionality. Recognizing that every choice—both personal and professional—contributes to the ongoing narrative of life and art fosters a heightened awareness of the present. We begin to see each encounter, each project, and each decision as part of a larger continuum, understanding that what we carry forward is not just a record of achievements, but a distillation of lessons learned, relationships nurtured, and insights gained.

The intersection of life and art also teaches resilience. Creative work is inherently uncertain; it often exposes one to criticism, rejection, and the inevitable unpredictability of external forces. By grounding creative expression in lived experience, we anchor ourselves in a source of stability. We learn that setbacks are part of a larger story, that challenges and triumphs alike contribute to growth, and that the art we create is inseparable from the journey we undertake. In essence, life informs art, and art reframes life, creating a dynamic feedback loop that continually expands understanding, empathy, and expression.

This synergy extends beyond the professional realm. The lessons learned from creative endeavors enrich personal relationships, deepen emotional awareness, and cultivate a sense of purpose. As we navigate life, we carry forward not only skills and memories but also the wisdom gleaned from our engagement with creativity. We learn to approach the world with curiosity, openness, and an appreciation for nuance, understanding that every experience—mundane or extraordinary—has the potential to inform and elevate both life and art.

In reflecting on this intersection, it becomes clear that moving forward is not a matter of abandoning the past but of integrating it. The experiences that shape us, the art we create, and the insights we gain form a cohesive continuum, a narrative thread that binds memory and aspiration. What we carry forward is not static; it evolves as we do, enriched by reflection, experimentation, and the ongoing dialogue between life and creative expression.

SECTION 3: Gratitude and Continuity – Finding Meaning in the Journey

Gratitude is often spoken of as a simple practice—an acknowledgment of what we have, of the kindnesses we have received, and of the opportunities we have been given. Yet gratitude is far more than a polite response or a fleeting emotion; it is a profound orientation toward life that shapes perception, resilience, and meaning. When looking back on a life filled with both ordinary and extraordinary experiences, gratitude serves as a bridge, connecting past and present, anchoring reflection in acknowledgment and appreciation.

In the context of personal reflection, gratitude allows us to recognize the contributions of those who have shaped our journey. Family, friends, mentors, collaborators, and even critics—each plays a role in molding our character, refining our skills, and expanding our perspective. Expressing gratitude is not merely an act of social courtesy; it is an exercise in clarity, helping us identify the forces that have sustained us and the moments that have defined us. In doing so, we come to understand the intricate web of influence, support, and inspiration that constitutes a life fully lived.

Continuity is equally vital in this reflective process. Life is rarely linear, and our journeys are often marked by shifts, disruptions, and transformations. Recognizing continuity—the threads that persist across time, the values that endure, and the lessons that recur—helps us construct a coherent narrative from disparate experiences. It allows us to see that even periods of uncertainty or hardship are part of a larger trajectory, contributing to growth, resilience, and insight. Continuity is the connective tissue that links memory to aspiration, providing a framework for understanding how past actions inform present choices and future potential.

Gratitude and continuity together cultivate a sense of meaning. They transform retrospection from a passive act into an active engagement with life, encouraging us to honor the journey rather than merely its outcomes. By appreciating what has been, we gain clarity on what matters most, guiding decisions and shaping intentions moving forward. This approach reframes success and failure alike, recognizing both as essential components of a life rich in experience, learning, and human connection.

Moreover, gratitude nurtures humility. Reflecting on achievements, opportunities, and even challenges through a lens of appreciation reminds us that no one navigates life entirely alone. Our paths are intertwined with those of others, and acknowledgment of this interdependence fosters empathy, compassion, and ethical awareness. Gratitude transforms reflection into a celebration of interconnectedness, highlighting the ways in which support, encouragement, and shared experience contribute to personal and collective growth.

Continuity, in turn, encourages purpose. Understanding the persistent themes, values, and lessons in our life story allows us to make choices that align with our authentic selves. It reinforces the idea that life is not a series of isolated events but a cohesive narrative, in which each chapter builds upon the previous ones, setting the stage for the next. By honoring continuity, we move forward with intentionality, guided by the wisdom of experience rather than the uncertainty of circumstance alone.

The process of looking back with gratitude and recognizing continuity ultimately leads to a more profound engagement with life. It allows us to appreciate the richness of our journey, to embrace complexity and contradiction, and to act with greater mindfulness and purpose. Every moment—every decision, every encounter, every creation—becomes part of a larger story, one that is imbued with meaning, connection, and insight.

Gratitude, then, is not static; it is dynamic. It informs the way we approach each day, the way we interact with others, and the way we perceive our own growth. Continuity reinforces this perspective, reminding us that we are part of an ongoing narrative that extends beyond individual accomplishments or setbacks. Together, they create a framework for reflection, learning, and forward movement, enabling us to navigate the future with awareness, compassion, and intentionality.

In embracing both gratitude and continuity, we cultivate resilience. Challenges become opportunities for reflection, setbacks transform into lessons, and achievements are celebrated not as endpoints but as milestones within a broader journey. This orientation fosters a sense of coherence, stability, and purpose, allowing us to move forward with confidence, curiosity, and openness to the unfolding possibilities of life.

Ultimately, looking back and moving forward is an act of synthesis. It combines reflection with action, memory with intention, and acknowledgment with aspiration. By engaging deeply with the lessons of the past, embracing the intersection of life and art, and cultivating gratitude and continuity, we are able to approach the future not as a series of unknowns but as a landscape rich with possibility, guided by insight, grounded in experience, and illuminated by meaning.

Conclusion

Chapter 5, "Looking Back, Moving Forward," invites a contemplation of life that is both deeply personal and universally resonant. Memoirs and musings illuminate the private terrain of thought, emotion, and experience, allowing us to reconcile with the past while clarifying the present. The intersection of life and art demonstrates how personal experiences inform creative expression and, conversely, how creative engagement shapes our understanding of life itself. Finally, gratitude and continuity offer a framework for finding meaning in the journey, fostering resilience, connection, and purpose.

Together, these reflections underscore a central truth: life is a continuous dialogue between what has been and what is yet to come. By looking back with insight, moving forward with intention, and embracing the lessons embedded in both, we navigate the path of existence with greater awareness, authenticity, and grace. Each moment, each decision, and each experience becomes part of an evolving story, one that is enriched by reflection, deepened by art, and sustained by gratitude. In this synthesis of past, present, and future, we discover not only who we are but also who we have the potential to become—a life lived with meaning, integrity, and the courage to move forward with open eyes and an open heart.

Printed and bound in the United Kingdom
17/11/2025
01998914-0003